CITY WITHIN A CITY

"The account of New York City's Chinatown moves from the tourist's view of an exotic place to a candid account of what it's like to grow up in those crowded, noisy, sometimes scary streets."
—*Booklist*

"These attractive debut titles in the *A World of My Own* series combine lively photography and simple text to introduce two very different communities."
—*Publishers Weekly* on *City Within a City* and *The Other Side*

"The warm, intimate photos show what's special about the kids and their neighborhoods and what is universal." —*Booklist*

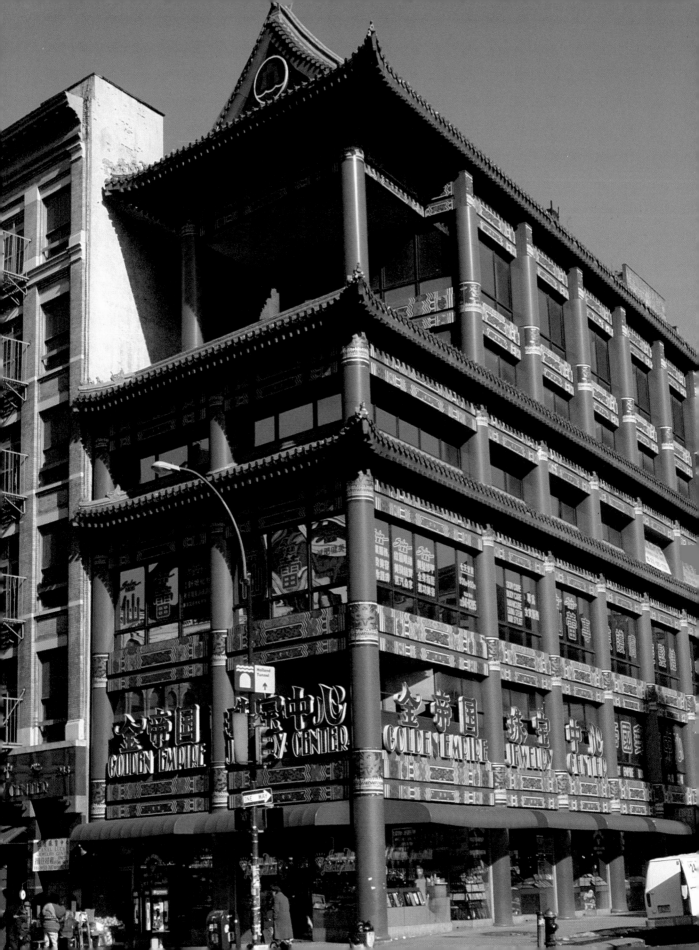

CITY WITHIN A CITY

How Kids Live in
New York's Chinatown

by Kathleen Krull
Photographs by David Hautzig

PUFFIN BOOKS

to Dr. Donna L. Keefe, L.Ac.,
extraordinary acupuncturist

—K. K.

to one of my most valuable assets—my friends: Stefan Zicht,
George Coleman, Jr., Ronnie Dinkins, Dev Hawley, Jay Greytok,
Nick Blaikie, Renee Chimpoukchis, Jessica Donohue,
Blake Logan, and Anton Hart

—D. H.

PUFFIN BOOKS
Published by the Penguin Group
Penguin Books USA Inc., 375 Hudson Street, New York, New York 10014, U.S.A.
Penguin Books Ltd, 27 Wrights Lane, London W8 5TZ, England
Penguin Books Australia Ltd, Ringwood, Victoria, Australia
Penguin Books Canada Ltd, 10 Alcorn Avenue, Toronto, Ontario, Canada M4V 3B2
Penguin Books (N.Z.) Ltd, 182–190 Wairau Road, Auckland 10, New Zealand
Penguin Books Ltd, Registered Offices: Harmondsworth, Middlesex, England

First published in the United States of America by Lodestar Books, an affiliate of Dutton Children's Books,
a division of Penguin Books USA Inc., 1994
Published simultaneously in Canada by McClelland & Stewart, Toronto
Published in Puffin Books, 1996

1 3 5 7 9 10 8 6 4 2

Text copyright © Kathleen Krull, 1994
Photographs copyright © David Hautzig, 1994
All rights reserved.

THE LIBRARY OF CONGRESS HAS CATALOGED THE LODESTAR EDITION AS FOLLOWS:
Krull, Kathleen.
City within a city: how kids live in New York's Chinatown / by Kathleen Krull ;
photographs by David Hautzig.—1st ed.
p. cm. —(A World of my own)
Summary: Describes the lives of two young Chinese Americans and their customs
and conditions at home in New York City's Chinatown.
ISBN 0–525–67437–3
1. Chinese American children—New York (N.Y.)—Social life and customs—Juvenile literature.
2. Chinatown (New York, N.Y.)—Social life and customs—Juvenile literature.
3. New York (N.Y.)—Social life and customs—Juvenile literature. [1. Chinese Americans.
2. Chinatown (New York, N.Y.)—Social life and customs.] I. Hautzig, David, ill. II. Title. III. Series.
F128.68.C47K78 1994
305.23'089'95107471—dc20 93–15846 CIP AC

Puffin Books ISBN 0-14-036520-6

Maps by Matthew Bergman
Printed in the United States of America.

Acknowledgments

The author gratefully acknowledges the participation of Sze Ki Chau and Chao Liu and their families, as well as the help of Karen Liu, director of the after-school programs for immigrant children at Chrystie Street Day Care Center of the Chinese-American Planning Council. Also helpful were Bonnie Farrier, Children's Librarian, Chatham Square Library; Marilyn Iarusso, Children's Services, New York Public Library; Leonard Marcus; Joy Chu; Bernard M. Lee; the Chinatown History Museum; Gery Greer and Bob Ruddick (and Wong Kee restaurant); and Virginia Buckley of Lodestar. Thank you to Paul Brewer. Special thanks to Jennifer Lyons, Michele Rubin, and especially Susan Cohen, of Writers House.

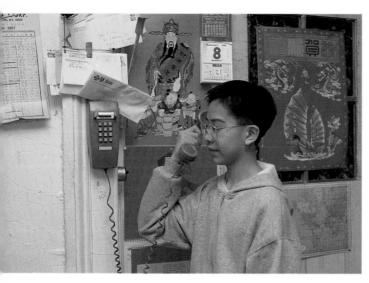

ABOVE: **Chao Liu, age twelve**

BELOW: **Sze Ki Chau, age twelve**

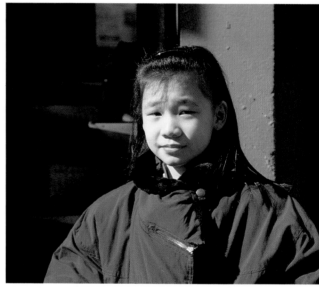

Chao Liu (pronounced *chow loo*) says his sister is "snotty." Or at least that's his response whenever she accuses him of having a big ego.

Like brothers everywhere, Chao, age twelve, often argues with his sister. But unlike most kids in the United States, Chao lives within a small section of New York City known as Chinatown. And when Chao's parents tell him to behave, they speak to him in Chinese. They know no English.

"Siblings are supposed to get along!" Chao translates. He understands them perfectly.

Most kids in Chinatown have to know two languages. Chao himself is more comfortable with English than Chinese. He was just a baby when he moved to the United States from the People's Republic of China, so English was his first language.

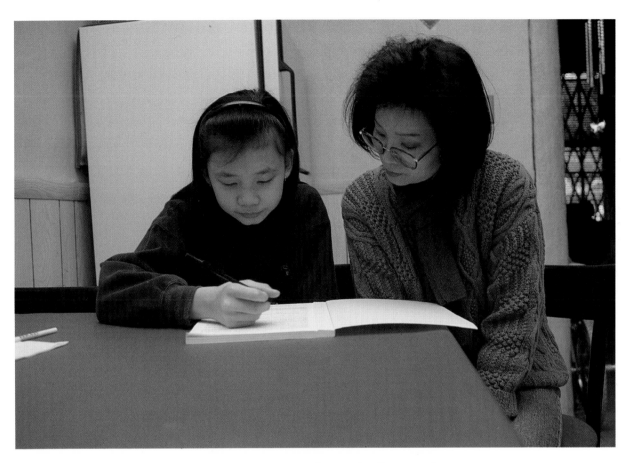

Sze Ki acts as a translator for her mother.

A few blocks away, Sze Ki Chau (*SAY kee chow*), age twelve, speaks not two languages but three. She talks to her mother in Mandarin and to her father in Cantonese, a completely different Chinese dialect. To people outside the family she speaks her third language, English, which she learned when she moved here from Hong Kong.

Now she is the translator for her parents, her seventeen-year-old brother Joe, and her eight-year-old sister Szewan (*SAY-wan*). She knows English better than anyone in her family. She is the one who helps her parents with any forms they have to fill out. They in turn can offer little help with her homework, except for math and art.

"It's just the way things are," Sze Ki says of her complicated language life.

Walking around the streets where Chao and Sze Ki live, you might forget for a while that you are in the United States.

All around you, people speak Chinese. The signs competing for your attention are all in Chinese, using characters (called ideographs) with no similarity to the English alphabet. In the shops, all the newspapers, magazines, and books are in Chinese. The streets confuse you—they're narrow, crooked, and jam-packed. Stands bursting with fruits and vegetables take up precious sidewalk space. Some of the foods are familiar-looking, but most—to an outsider—could be from another planet. The smell of fresh fish, flown in daily from China, mingles with the scent of incense from Buddhist temples. Telephone booths look like miniature pagodas. There are no street people or

FACING PAGE: **Telephone booth in Chinatown**

BELOW: **Fish market in Chinatown**

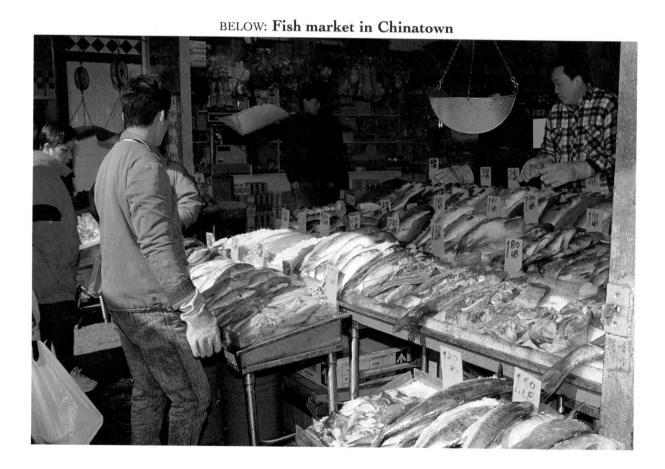

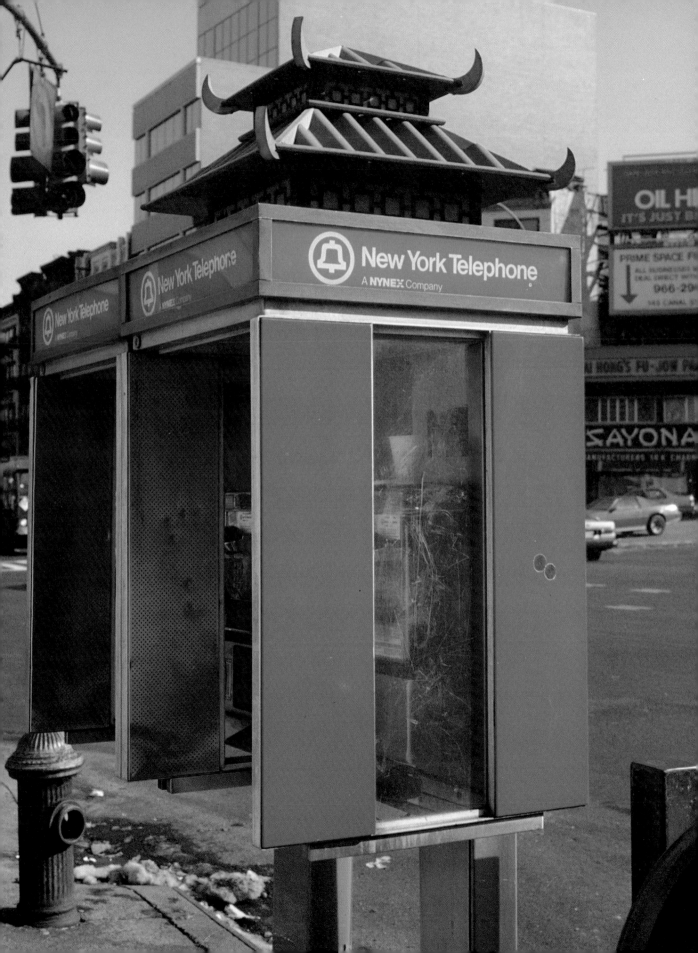

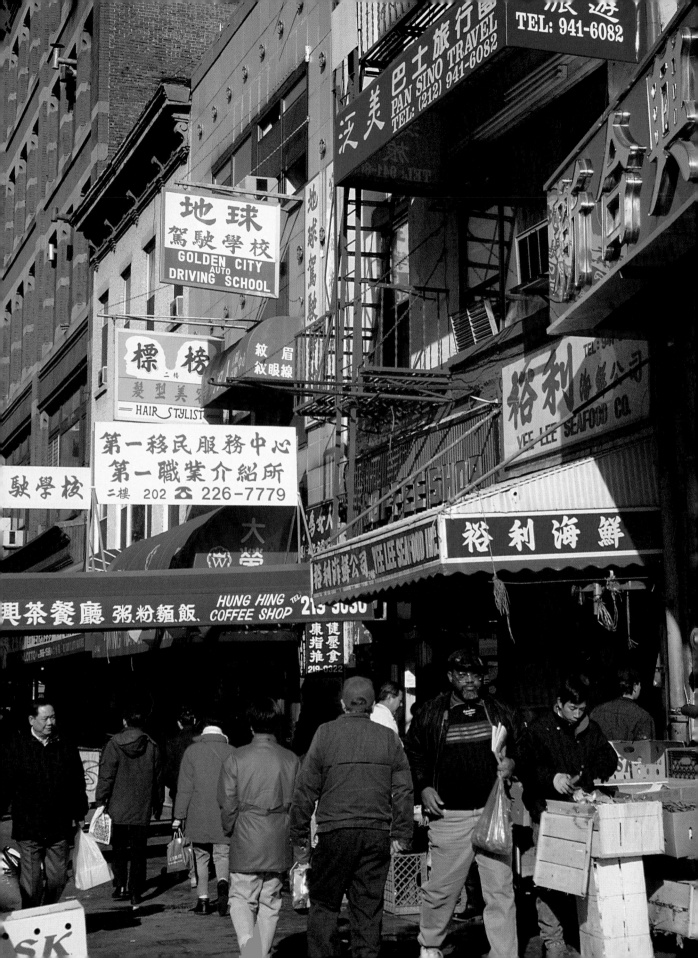

folks just sitting around; everyone seems to have a mission—an urgent one. Amid the churning sensations, it is easy for outsiders to get flustered and wonder where they are.

Tourists crowd into Chinatown—up to half a million on a sunny Sunday—attracted by the energy of its street life. There are restaurants with wonderful food at reasonable prices; markets with fresh

FACING PAGE: **Chinatown street signs**

BELOW: **Busy people crowd the streets.**

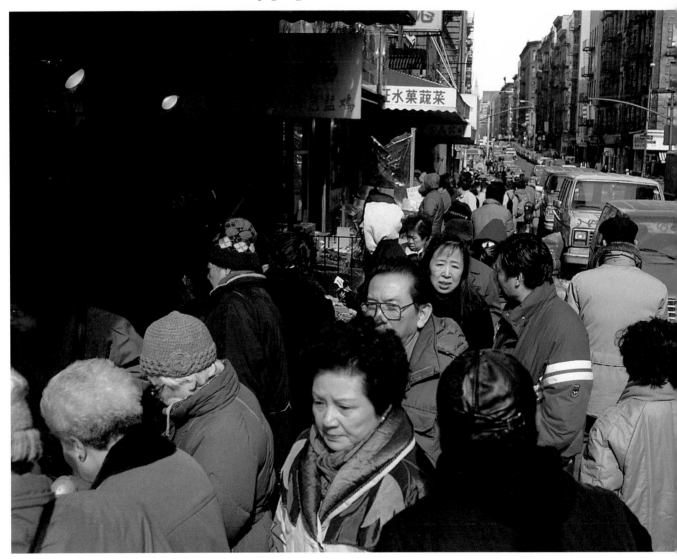

Where Is Chinatown?

Chinatown takes up about three square miles of Manhattan, in New York City. Its borders are roughly East Houston Street to the north, the East River to the east, the South Street Seaport to the south, and Broadway to the west. It is home to the largest Chinese-American community in the United States. Today it is bigger than ever, expanding into the Jewish and Italian neighborhoods surrounding it. New York City is the first choice of Chinese immigrants from all parts of the world, and continued growth of Chinatown is expected. In 1997, the city of Hong Kong, currently a British colony, returns to Chinese control, and it is expected that many Chinese will be fleeing communist rule and emigrating to the United States.

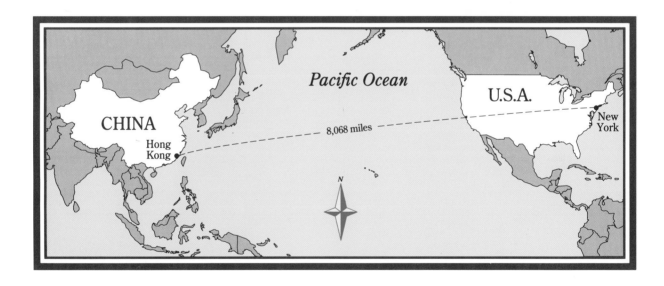

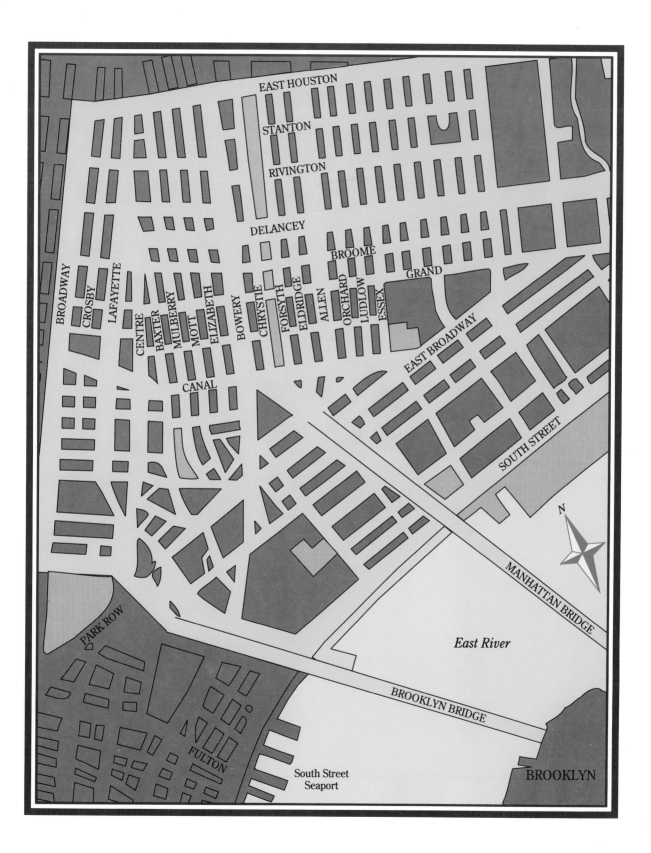

Chinese restaurants attract tourists.

ingredients; street peddlers; Chinese opera performances and art exhibits; herbalists and acupuncturists; and fascinating shops with kites, framed calligraphy, screens, porcelain tea sets and figurines, brocade slippers, and other imported goods. Tourists love the feeling of traveling to a foreign country without leaving the United States. They eat and shop, then go back to their own homes.

But what about those who remain after the tourists leave? Who lives in this intriguing area?

Chinatown is a home for new immigrants. The majority of residents, about 80

Street market with fresh vegetables and herbs

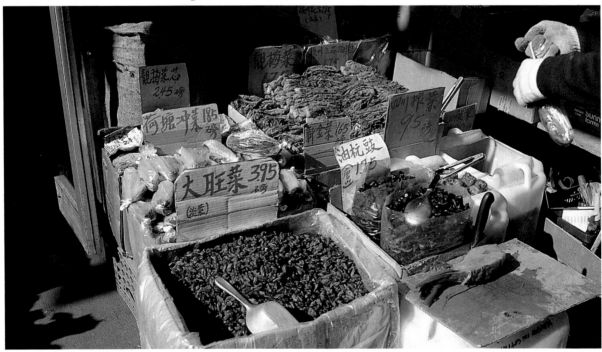

percent, are recent arrivals from China. They have not come for sight-seeing or pleasure. For the most part they are escaping political repression, terrible poverty, or rigid laws that discourage individuality. To get to what is known in China as "the beautiful country," most Chinese immigrants have made a longer, riskier, and more complicated journey than recent newcomers of any other ethnic group in the United States.

Once settled, people tend to work hard. Banks, restaurants, pharmacies, garment factories, and jewelry shops are open seven days a week. Chinatown encourages tourism as a way for its residents to make money in the community without encountering outside prejudice.

New arrivals take great pains to save money. As soon as they have enough to move to a place where housing and living conditions are better, they usually do.

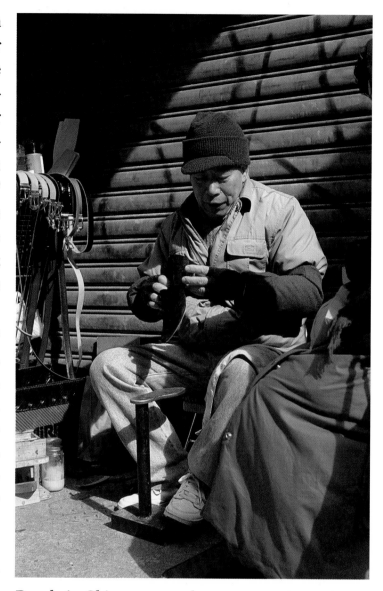

People in Chinatown, such as this shoe repairman, work hard.

Satellite Chinatowns, in Brooklyn and in Flushing, Queens, are the most popular destinations. But somehow this neighborhood, in Manhattan's Lower East Side, never shrinks. It is constantly being refreshed by waves of yet more new arrivals.

How Did Chinatown Begin?

One-fifth of all the people in the world live in China. Because of poverty, Chinese began emigrating to the United States during California's gold rush. They dug for gold; then, as whites limited their job opportunities, they opened laundries, worked as migrant farm laborers, and did most of the manual labor in building the railroads connecting East and West. In 1880, Chinese were such a novelty in New York that P. T. Barnum put a Chinese person on display in a carnival. When the railroads were finished and violent, racist persecution began, Chinese began moving east. They formed Chinatowns—self-contained, self-sufficient neighborhoods with their own rules, language, and culture—usually located in a run-down, outlying area of a city. Cities within cities were safe places to earn a living without fighting the prejudice of whites. During World War II, in which the Americans and Chinese were allies, Americans began treating Chinese with more respect. When discriminatory immigration laws finally ended, the growth of New York's Chinatown became dramatic. Between 1980 and 1990, the population doubled. In all of New York City, at least 250,000 Chinese-Americans live legally (and more live illegally)—more than one in twenty New Yorkers is now Chinese-American.

Chao Liu likes Manhattan because it's cleaner and cooler than China, with fewer mosquitos and other insects. He enjoys the access to the shops, libraries, and restaurants of the city. But he and his family are looking forward to living somewhere else. His parents even have a date picked out—one year away—when they want to move from Chinatown to Brooklyn.

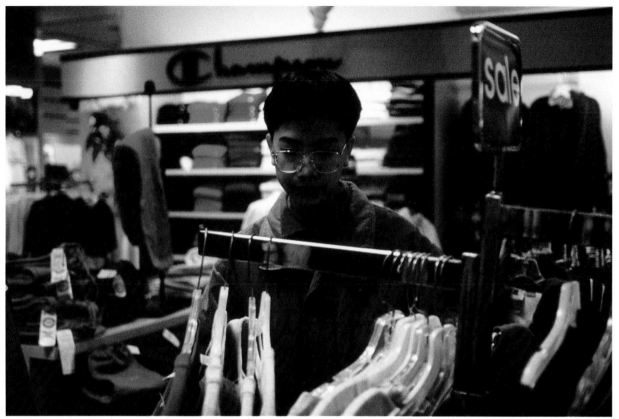

Chao enjoys shopping more in the United States than he did in China.

"It's not a very good place to live," says Chao about his current neighborhood. "Too much noise, lots of really old buildings. Too many people. The street I live on is too busy and noisy, like a highway." The minute you step out of Chao's apartment building, you can hear the loud wail of police sirens.

Sze Ki Chau says that life in Chinatown can be convenient, "especially for fresh food at good prices." But the high rate of crime here scares her. Her impression is that people are nicer elsewhere. Although families take care of their relatives—you don't see homeless people here, for example—they have little energy left over to improve the community. In Chinatown, says Sze Ki, "the people are too busy to be nice." Her parents are also planning to move the family as soon as they can.

Chao's parents both work six days a week. His mother, a seamstress, sews zippers into dresses, and his father is a cook in a restaurant. His sister, Lily, works at the day-care center where she and Chao used to go after school. Chao doesn't have a job—yet. He gets an allowance that gives him money for snacks and tapes of American popular music.

Sze Ki gets an allowance, too, which she spends on magazines, treats, and additions to her large tape collection. Her mother works at a bank. Her father, who was a newspaper cartoonist in Hong Kong, works as a cook in Atlantic City, New Jersey; Sze Ki sees him only on weekends.

Chinatown apartments are small and crowded. Sze Ki lives with her whole family and large dog, Bobo, in four tiny rooms. Some of the oldest housing in New York City is in this area, much of it built over a hundred years ago.

Chao's sister, Lily, works at a day-care center.

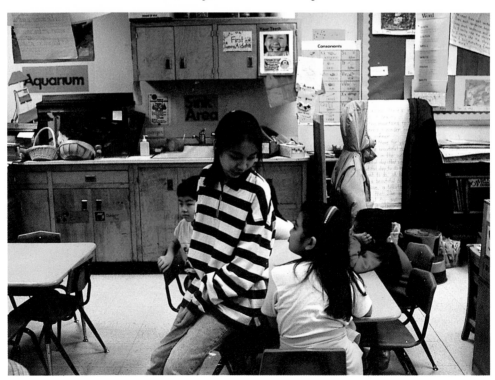

Sze Ki shops for new tapes to add to her collection.

Sze Ki shares an apartment with her parents, siblings, and Bobo, the dog.

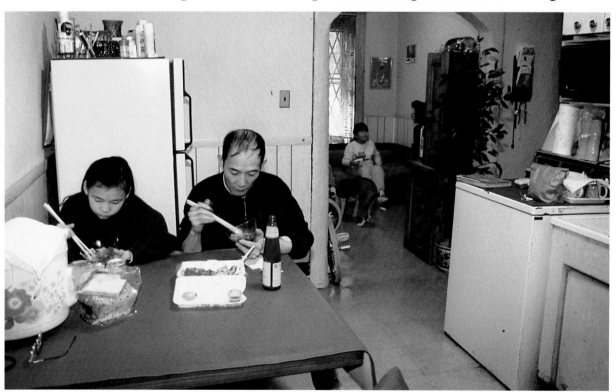

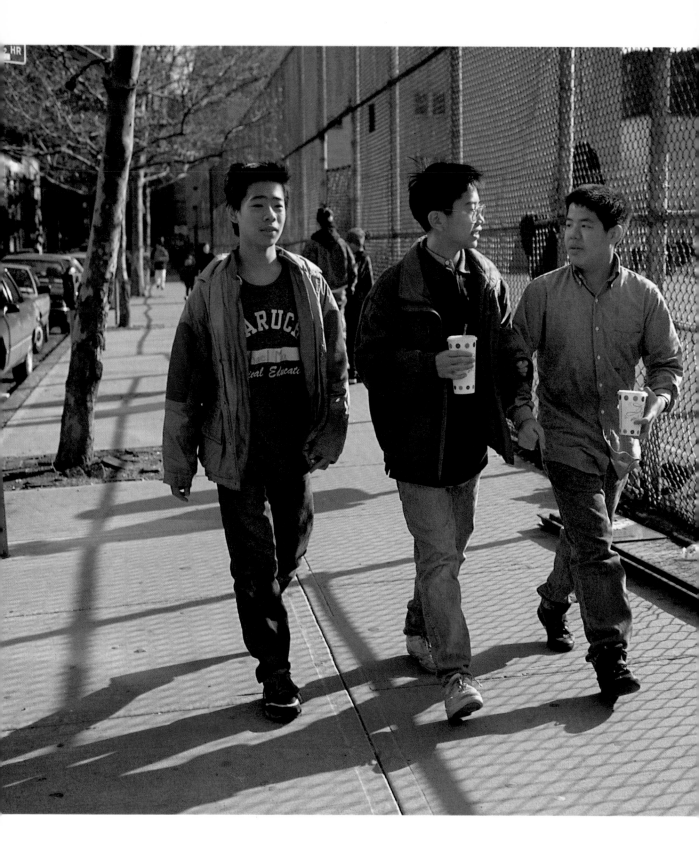

Kids who move here find it scary to be in a new place that has a language they cannot speak, read, or write. Because of the language difference, they are made fun of at school, liable to fall behind in their classwork, and have feelings of loneliness, helplessness, and frustration. People in Chinatown can be reluctant to report crimes because of language problems. But crime is just one of many things kids here have to worry about. They also fear strange surroundings and not living up to their families' expectations. Finally, kids may be scared of racism outside Chinatown. They may hear that people will harass them for simply being Chinese.

Chao says he is not especially scared to go outside Chinatown, unless he finds himself on a "really quiet" street with no people. Other kids seldom attack him because "I'm taller than them." If they do, sometimes he hits back, and sometimes he just "leaves it"—walks away. When fights break out near him, he tries to stay uninvolved. His impression is that tough kids pick on smaller kids, and that one's ethnic background can be a source for insults. He says, "Hispanic kids come up to you and say *Chino*," which means "Chinese" in Spanish. Chao tries to ignore them for fear they will call on bigger kids to get back at him later. Talking back only makes it worse in the end.

Sze Ki has also seen evidence of racism. Recently she was in a candy store when a Chinese boy asked his non-Chinese friend if he could borrow some money; the friend replied, "I don't lend money to Chinos."

Chao walks with friends near his school.

21

Signs of gang activity in Chinatown

She seldom leaves Chinatown. "My family is busy," she explains; they have no time to accompany her to other places. Her teachers constantly warn against street gangs. She knows gangs exist in Chinatown and also come in from different places, but she ignores them and doesn't talk about them much with friends.

Neither Sze Ki nor Chao travels alone on the subway. They know the rules for any kids in a big city: Don't look scared; don't look down; don't explore alone. Chao and his sister are not allowed to go out unless an adult is with them; on weekends, when both parents are working, this means that he and his sister must spend whole days inside their little apartment.

Even things that look like fun—to tourists—can be scary. The Chinese New Year, for example, is the most festive day in Chinatown. This celebration of the new year, in January or February (depending on the cycle of the moon), is one day when businesses do close. People mark it with feasts, prayers, parades, and lots of money gifts (in small red envelopes) given to children. At night, so many firecrackers explode that the thick smoke is visible for blocks around. For children, the pandemonium of fireworks, drums, bells, and thousands of partying tourists can be more frightening than festive.

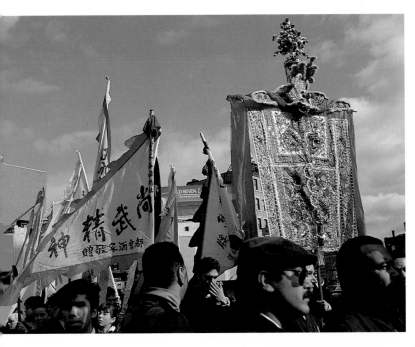

Chinese New Year parade

Children are not forgotten during the Chinese New Year.

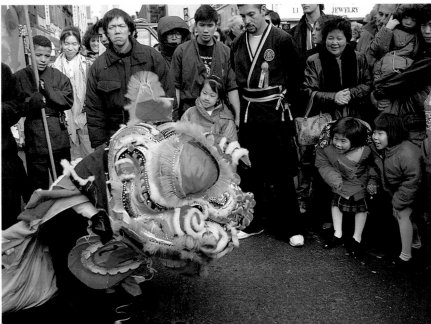

Kids can worry about pressure from their parents. New immigrants in Chinatown assume that their children will do much better in life than they did and that the children will end up taking care of the parents. Going to college is usually a given, with more of an emphasis on practical careers than on the arts. Kids are expected to take homework seriously; the Chatham Square Library in Chinatown is said to be the busiest library in all of Manhattan. The two most popular career choices, one librarian observes, are computer science and pharmacy.

Sze Ki definitely knows what she's going to be: a doctor. She is fascinated by the human body and how it works. Chao doesn't know yet what career he will choose, but he thinks it will have something to do with science, his best subject. His parents are proud of him already; the first thing visible in their apartment is a wall of school awards and trophies won by him and Lily.

Doing homework at the library

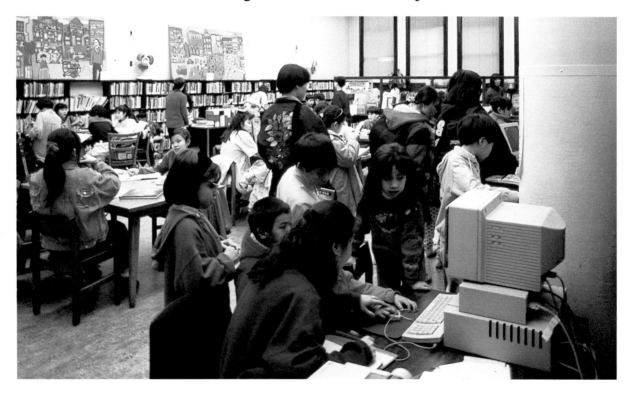

Chao studies, surrounded by school awards he has won.

Stereotypes

Asian-Americans, at 3 percent of the total U.S. population, are currently the fastest growing minority in the United States. Besides China, they come from Japan, Vietnam, the Philippines, Korea, Laos, India, and other countries that are all very different from one another. It is a mistake to think that Asian-Americans, as a group, are all alike; most do not consider themselves Asian-Americans until they move here and are so labeled. Most now consider Oriental *a racist term. It evokes outdated stereotypes from old movies and defines people from a Western point of view.*

Because more Chinese-Americans who enter college complete it than whites, they are sometimes called the "Model Minority." Many kids dislike this label, as it puts pressure on them to always excel. The label itself is another example of a limited, white point of view—it measures people by how fast they learn English and assimilate into middle-class American culture. As well as being unfair to other ethnic groups, it ignores the individuality of kids like Sze Ki Chau and Chao Liu.

Kids in Chinatown have stereotypes, too: Americans can strike them as rude and lazy, and they don't seem to place enough value on education and family. "Policemen are not strict enough," several kids declared. They think criminals get off too easily, that people here are almost too free. Americans seem to be willing to do anything for money, including breaking laws.

Americans from Korea (LEFT), Japan (FACING PAGE), and China may feel little in common with one another.

The first generation of Chinese to arrive in the United States tend to marry among themselves, but their children usually have more freedom. Chao's friends are a mix of Chinese and kids from other ethnic backgrounds; his school is primarily Chinese, Polish, and Latino. Most of Sze Ki's friends are Chinese, though she gets along well with several Latino girls at her school. Neither Sze Ki nor Chao knows kids

Chao and his friends play video games near his school.

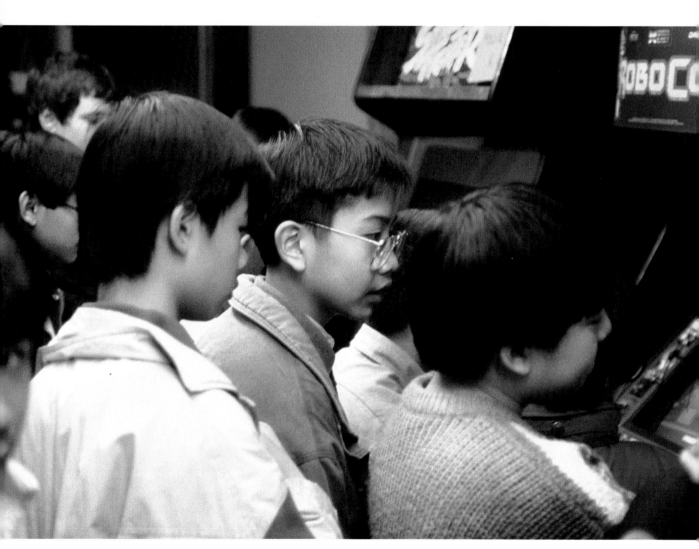

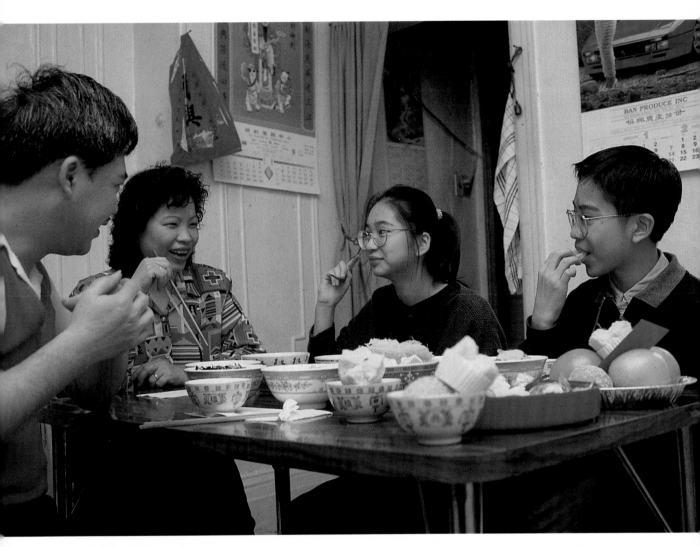

Chao and his family celebrate the Chinese New Year with a special meal.

from other Asian countries besides China. Chao's parents don't mind if he has non-Chinese friends, but they do pay attention to whether they are "bad"—into smoking, drugs, fighting, or stealing—or "good." His mother gets upset if he wants to go to the movies with someone she doesn't know.

"My mom is more Chinese than American," says Chao. "Americans let kids go anywhere they want, but Chinese are really strict."

Chao, like many kids, may believe his parents are stricter than everyone else's, but, in fact, some people would agree with him. Traditional Chinese culture is based on respect for elders, and the discipline placed on children can lead them to think they must be perfect at all times. On the other hand, once the family is in the United States, its usual balance can be thrown off by the children's early superiority in English. Parents are frequently too busy working to take time out for classes in English. When kids are acting as family translators, they grow up faster and take on responsibilities they wouldn't have had in China. "I feel more American than Chinese," says Chao.

Sze Ki's knowledge of languages can be useful when she's shopping with her mother.

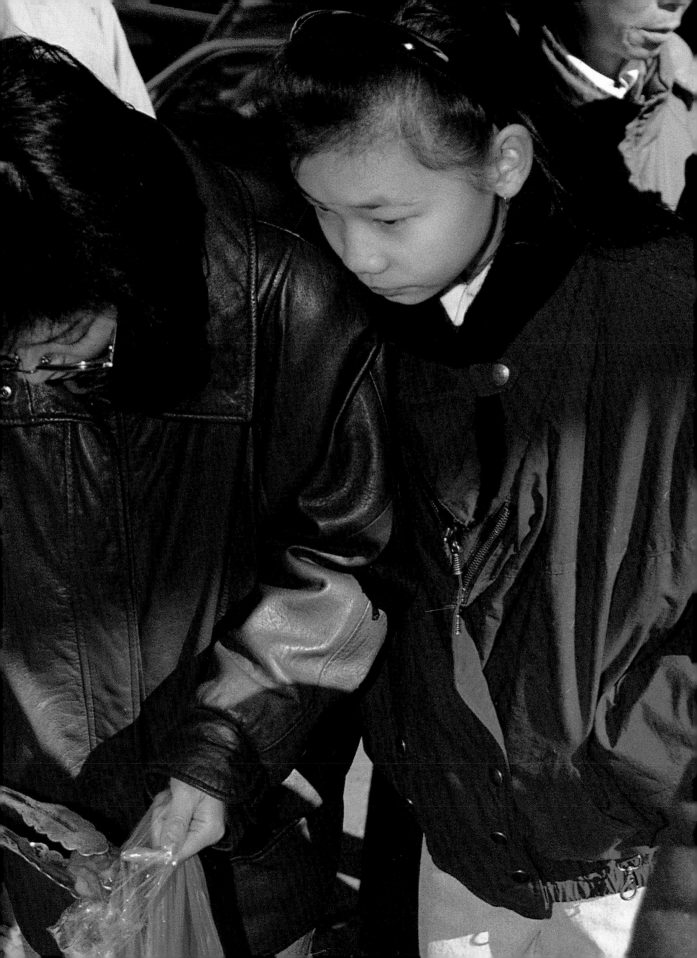

Chao's biggest conflict with his parents happens when he hits his sister. He isn't punished physically, just lectured. "Lily," he sighs, "never gets in trouble."

Sze Ki says she doesn't get in trouble, either. Once her parents were called into school because of a report that she was fooling around, but it turned out to be a case of mistaken identity.

Sze Ki's family tries to keep some connections between their old life and their new one in New York. The main thing she remembers from her first five years in Hong Kong, for example, is the Moon Festival, a time of thankfulness much like the American Thanksgiving. The next biggest holiday after New Year, the Moon Festival takes place eight months later, when the moon is said to be at its brightest. "In Hong Kong my friends and I used to go up to the roof, light candles, and eat moon cakes," Sze Ki says. Moon cakes are thick and round, sticky-sweet, made of lotus seed paste and filled with egg yolks or candied fruit. According to legend, secret messages used to be passed around inside moon cakes during the reign of an evil emperor. After eating half a moon cake, Sze Ki doesn't need to eat for hours.

Moon cakes, a treat during the Moon Festival

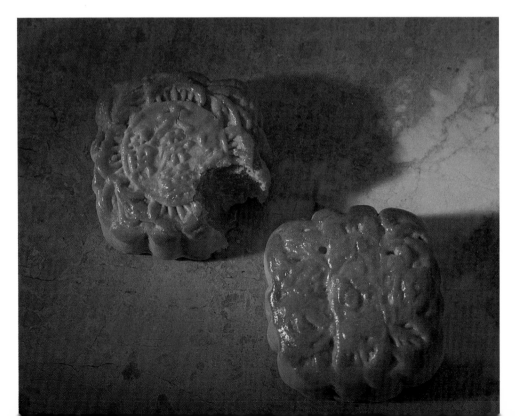

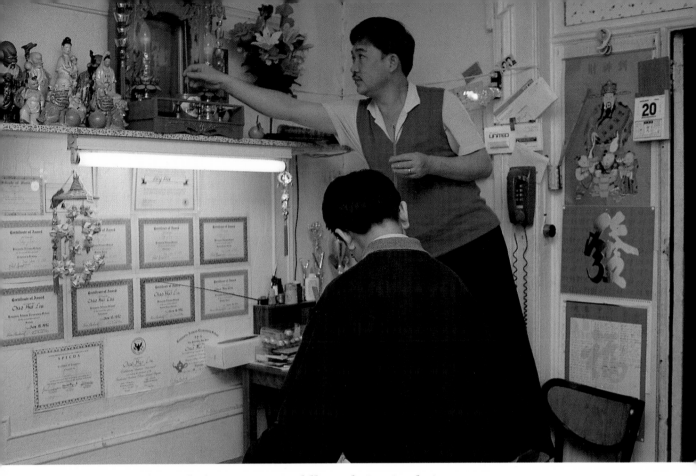

Chao's father puts a Buddhist shrine in their apartment.

In New York, Sze Ki's roof is not fenced off and safe, so her family celebrates in their apartment. To mark the festival this year, her mom cooked Chinese beef stew, and they had a gigantic "pig-out." No moon cakes, though—Sze Ki's family couldn't wait for the actual Moon Festival and ate them in advance.

Of Chinese holidays like the Moon Festival, Chao says, "I don't really follow them." His parents celebrate things he knows little about. For instance, they set up their version of a Buddhist shrine in their living room for the Moon Festival, with moon cakes in the window and incense. But they haven't taught him what any of this means, and they don't seem to mind that he doesn't know. He celebrates Christmas at school, and in general, he spends more time with friends than with family.

Chao has watched neighbors practicing a mysterious form of shadow-boxing using slow, stylized movements. Until recently, he wasn't aware that this was tai chi—a Chinese discipline; he thought they were just "old people doing slow-motion exercises." His parents have Chinese herbs around the house and took him to an acupuncturist when he was little, but now, when he gets sick, he sees Western doctors, not Chinese.

FACING PAGE: **Practicing tai chi in a Chinatown park**

BELOW: **Stores carry Chinese herbs.**

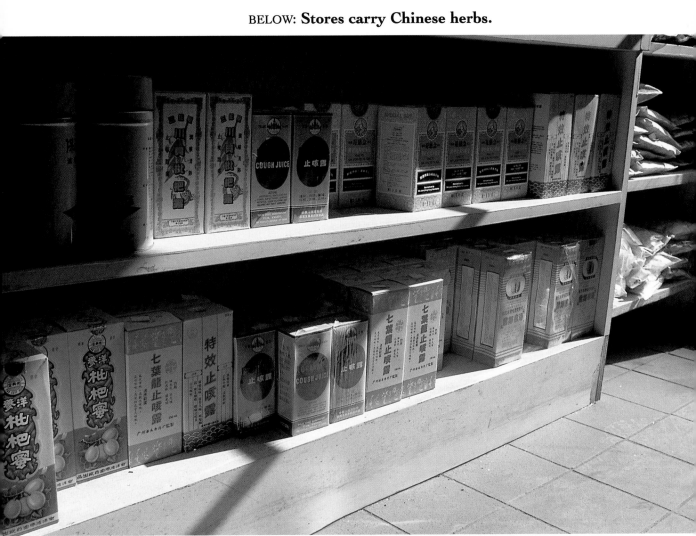

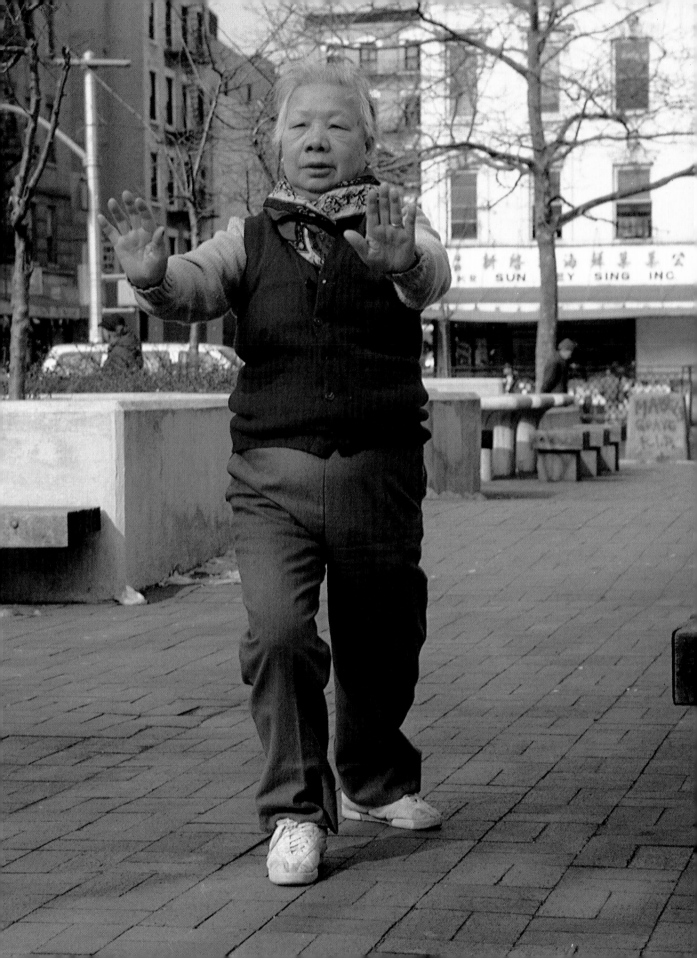

Chinese Medicine

In the fifteenth century, China was considered the richest, most advanced nation on earth. The Chinese were the first to develop the compass, the clock, paper, movable type, silk, porcelain, gunpowder and fireworks, orange trees, spaghetti, and paddleboats. Their traditional system of medicine, acupuncture, which uses needles to prevent and cure disease, goes back at least three thousand years. Now acupuncture is one of the fastest growing health care techniques in the United States, with the number of qualified acupuncturists going from two hundred in 1978 to five thousand in 1988. There are almost as many doctors in New York's Chinatown as there are restaurants. The World Health Organization lists fifty common disorders that it believes acupuncture is effective in treating. A fully trained acupuncturist is also an herbalist with access to three thousand herbs—no country has catalogued its herbs as completely as China.

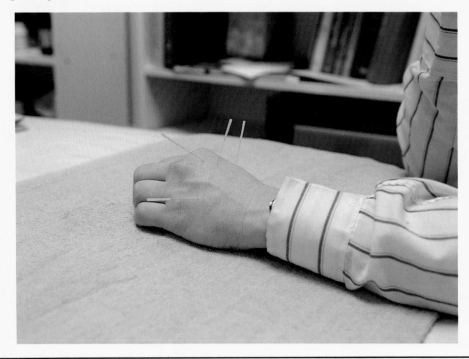

Sze Ki occasionally goes to a Buddhist temple.

Chao doesn't know when his parents' birthdays are or even their true ages. This fits in with traditional Chinese culture, in which individual birthdays are thought unimportant and everyone simply adds a year to his or her age on New Year's Day. Chao celebrates his own birthday with friends.

Sze Ki's family, on the other hand, likes the custom of celebrating birthdays and has adopted it. Her parents ask if the kids want anything and will try their best to get it.

In China, religious beliefs are discouraged, and here in Chinatown, they do not seem to play a big role. Many kids go to Catholic schools, but they aren't necessarily Catholic. Sze Ki's mother is Buddhist, and sometimes Sze Ki goes with her to the temple across the street. But she hasn't decided yet if she will join a church—her parents leave that up to her.

Chao thinks his parents are Buddhist, though he is not sure. They practice vegetarianism on certain days and perform a monthly incense ceremony, trying to teach Chao by example. But, he admits, "I don't really pay attention."

Speaking of Food . . .

Anyone who likes eating in Chinese restaurants will think Chinatown is heaven. There are hundreds of family-run restaurants that open early and close late. Specialties include lots of dishes with crunchy vegetables such as water chestnuts, bamboo shoots, bok choy, snowpea pods, bean sprouts; hot and spicy foods; moo shu pork (wrapped in pancakes); spring rolls; sizzling rice soup; Chinese noodles served in various ways; and pressed duck. Sauces include soy, oyster, plum, and garlic. Dim sum (which means "touch the heart") refers to an assortment of appetizers, mostly different kinds of delicious dumplings and steamed buns, that is wheeled to your table. You point to what you want. For dessert there's ice cream— almond cookie, lychee, ginger, mango; cookies sculpted into fish or birds; bananas dipped in honey and sesame seeds; and coconut bread. And lots of tea, from black to green, from chrysanthemum to jasmine. Chop suey, incidentally, was invented in Chicago and is not considered a particularly Chinese dish.

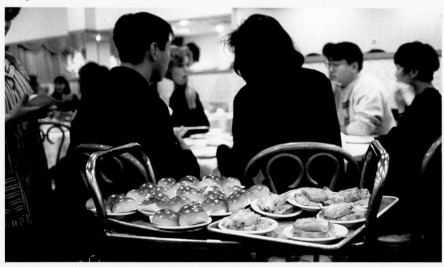

Dim sum in a Chinese restaurant

Chao eats only Chinese dishes at home and says that he is close to disliking Chinese food because he grew up with so much of it. Away from home he eats cheeseburgers, pizza, Mexican food, and especially Vietnamese food. He loves Vietnamese dishes such as pork chops and vegetables, which use different spices and are cooked differently from Chinese food.

At home Sze Ki also eats primarily Chinese food, like rice with tomatoes and beef cooked in a wok with Chinese spices. But she prefers it. When she goes out, she'd rather have soup with noodles and seafood at a Chinese restaurant than a hamburger in an American restaurant.

Both Chao and Sze Ki usually come home straight from school, work hard on homework, and have little free time. They have fun the same way other American kids do. They listen to American radio stations, not Chinese. Sze Ki likes to read, from Judy Blume to Mary Higgins Clark. At school she sings in a chorus, and in a spring garden program she plants sunflowers. Chao reads mysteries and Archie comic books. He goes to movies, the park near his house, and by train to the malls in New Jersey. He likes the Yankees, and at school, he enjoys basketball and volleyball games between students and teachers.

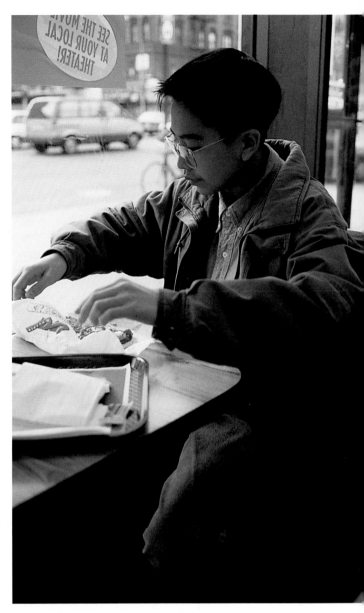

Chao has one of his favorite meals, a cheeseburger.

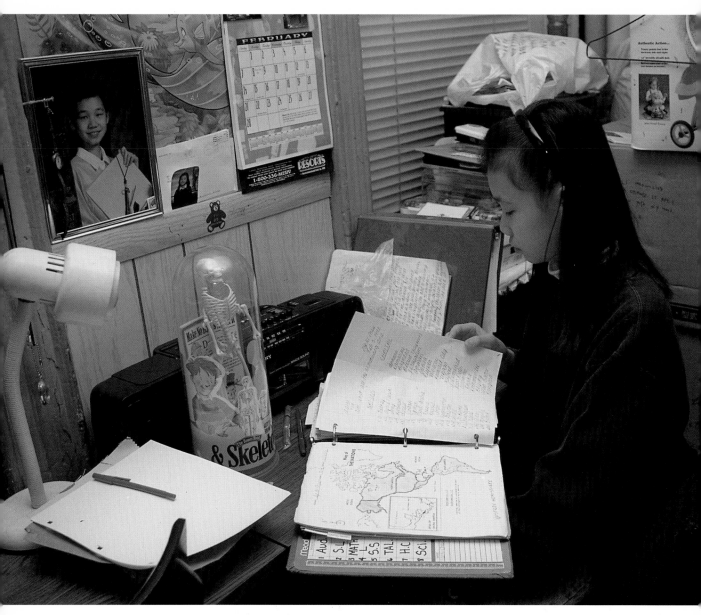

Sze Ki usually does her homework immediately after school.

There are two Chinese TV stations. Chao doesn't like them—his favorite shows are the same ones most American kids like—but his mother does. Whenever they fight over the TV, his mother always wins. Sze Ki thinks Chinese comedies are funnier than American

ones, but she watches American shows, too. She doesn't have to argue with her parents about the TV because the family has two.

Both Sze Ki and Chao have traveled with their parents to other states, visiting relatives. They are aware that Chinatown is in many ways another world and that not many people know about it.

Sze Ki sings in the school chorus.

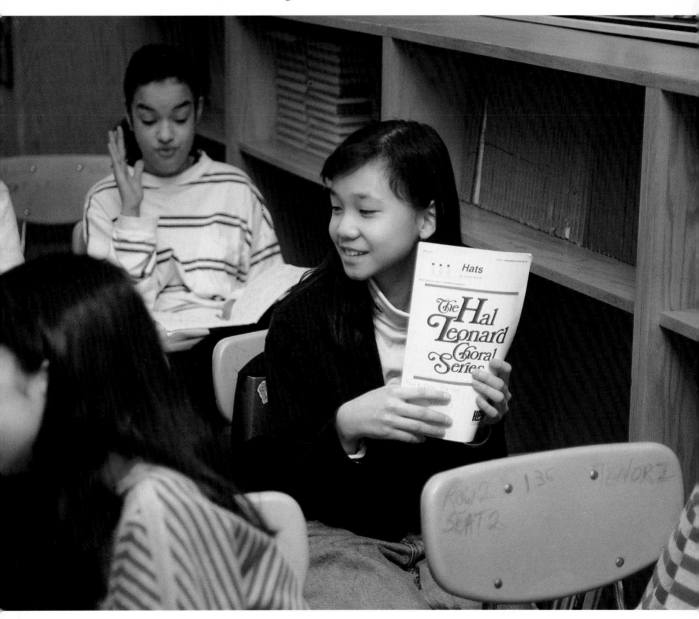

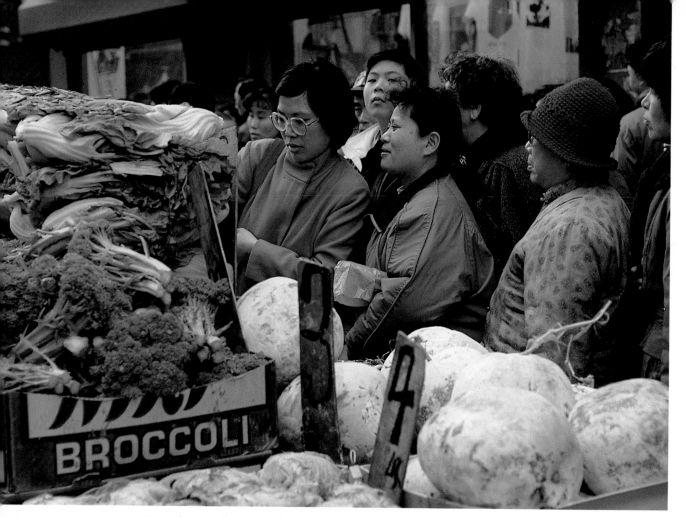

People in Chinatown like to live quiet lives, out of the limelight.

For various reasons, people in Chinatown tend to avoid publicity. In the past, when attention was paid to Chinese in the United States, it was usually negative and encouraged discrimination and outright persecution. This has led to a tendency for people to distrust outsiders or at least stay out of the limelight. Freedom of speech and freedom of expression are new concepts to Chinese in this country, and many are not aware they can't be punished for expressing their beliefs. Also, it is estimated that one out of five people in Chinatown is undocumented, or someone who has entered the United States illegally. These people live in fear of being discovered and sent back to China, and they are anxious to remain invisible.

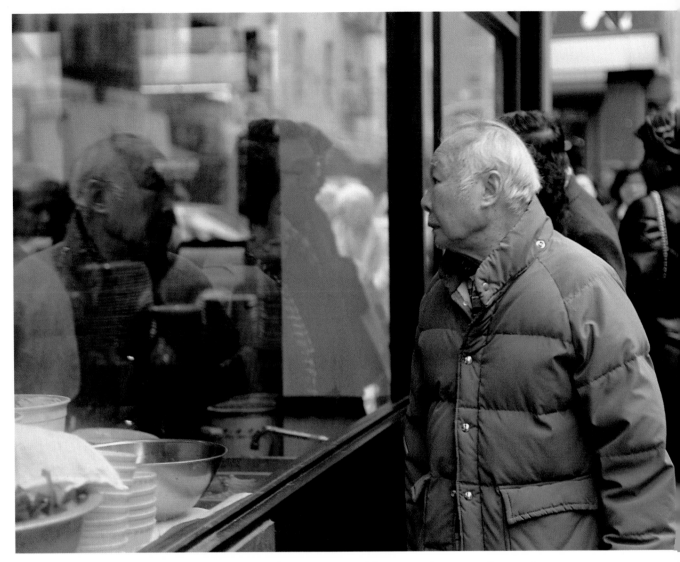

Discrimination leads many Chinatown residents to keep to themselves.

Finally, according to traditional Chinese culture, anything resembling showing off will bring bad luck. Therefore it is better to live as inconspicuously as possible. So, for outsiders, information about Chinatown can be hard to get. Some observers think that much of the information that does come out is inaccurate or exaggerated, especially the emphasis on things like crime, gangs, and drugs.

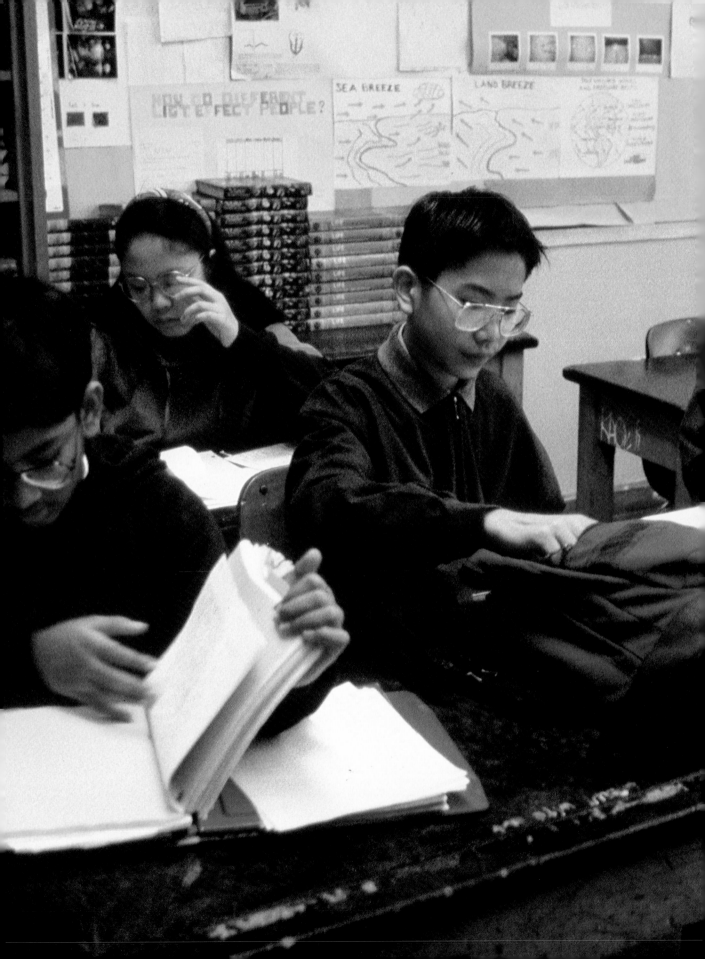

Chao and Sze Ki are unusual in that they are not shy about wanting outsiders to know what Chinatown is really like. Chao wishes there were more movies and books about Chinatown, "to show kids in Iowa how different things are here." The only related book Sze Ki knows about is on famous Chinese-Americans. She agrees that most kids don't know anything about how she lives.

Neither Chao nor Sze Ki plans to return to China except to visit relatives. Perhaps they will be responsible, when they grow up, for further publicizing life in Chinatown. Meanwhile, Sze Ki, with her curiosity about how bodies work, works hard toward becoming a doctor. And Chao is saving money for his career in science.

But part of Chao also wonders if it wouldn't be fun to open an ethnic restaurant, say Vietnamese, in a quiet, rural area of America, to provide food that the local people have never tasted before. Such a place, far from Chinatown's plentiful restaurants, would have little competition and would "get a lot of customers."

And part of Sze Ki is intrigued with the idea of becoming a model. After all, it's another kind of focus on the human body.

One thing seems certain: Sze Ki and Chao are well on their way to making the best of their life in Chinatown—and beyond.

**Chao plans a career in science,
one of his favorite subjects in school.**

45

For Further Reading

Brown, Tricia. *Chinese New Year.* New York: Holt, 1987.

Hou-tien, Cheng. *The Chinese New Year.* New York: Holt, 1976.

Kinkead, Gwen. *Chinatown.* New York: HarperCollins, 1992.
 (for adults)

Kwong, Peter. *The New Chinatown.* New York: Hill and Wang, 1987.
 (for adults)

Leeds, Mike. *The Passport Guide to Ethnic New York.* Lincolnwood,
 Ill.: Passport Books, 1991. (for adults)

Mayberry, Jodine. *Chinese.* New York: Franklin Watts, 1990.

Meltzer, Milton. *The Chinese Americans.* New York: Crowell, 1980.

Sung, Betty Lee. *An Album of Chinese Americans.* New York:
 Franklin Watts, 1977.

Waters, Kate, and Madeline Slovenz-Low. *Lion Dancer: Ernie Wan's
 Chinese New Year.* New York: Scholastic, 1990.

Index

Page numbers in *italics* refer to photographs and maps.